The Channel Islands
Colouring Book

First published 2016
Reprinted 2019

The History Press
The Mill, Brimscombe Port
Stroud, Gloucestershire, GL5 2QG
www.thehistorypress.co.uk

British Library Cataloguing in Publication Data.
A catalogue record for this book is available from the British Library.

ISBN 978 0 7509 6761 7

Cover colouring by Lucy Hester.
Typesetting and origination by The History Press
Printed and bound by Imak, Turkey

THE CHANNEL ISLANDS
COLOURING BOOK

PAST AND PRESENT

Take some time out of your busy life to relax and unwind with this feel-good colouring book designed for everyone who loves the Channel Islands.

Absorb yourself in the simple action of colouring in the scenes and settings from around the Channel Islands, past and present. From iconic architecture to picturesque vistas, you are sure to find some of your favourite locations waiting to be transformed with a splash of colour. Bring these scenes alive as you de-stress with this inspiring and calming colouring book.

There are no rules – choose any page and any choice of colouring pens or pencils you like to create your own unique, colourful and creative illustrations.

Alderney train, made from
former Tube train carriages ▸

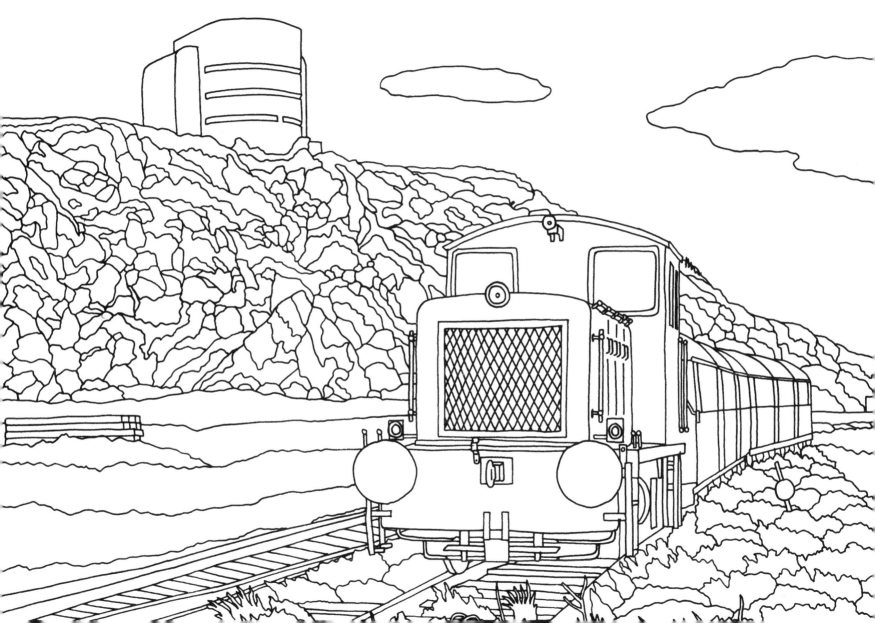

Bray Beach, Alderney ▸

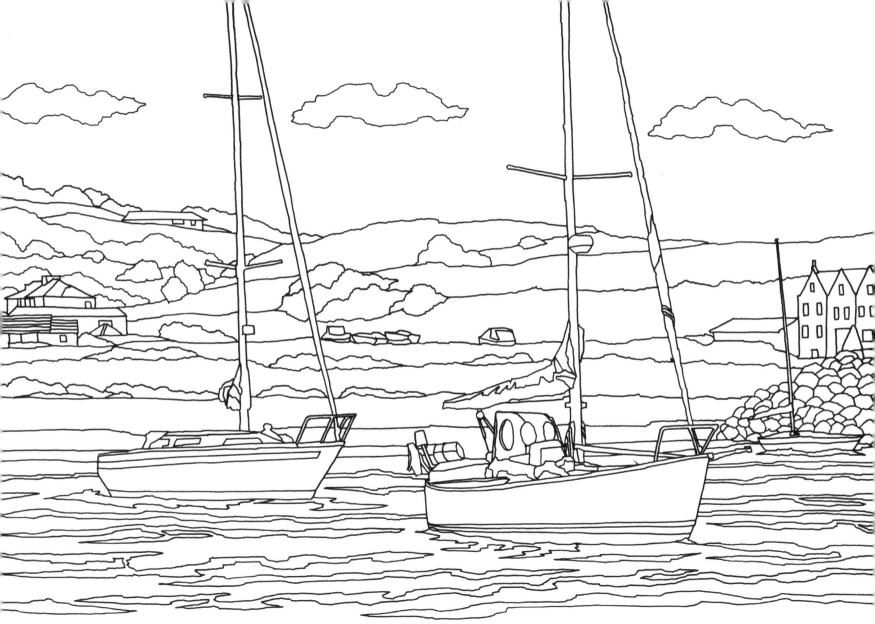

La Rocco Tower, St Ouen's Bay, Jersey ▸

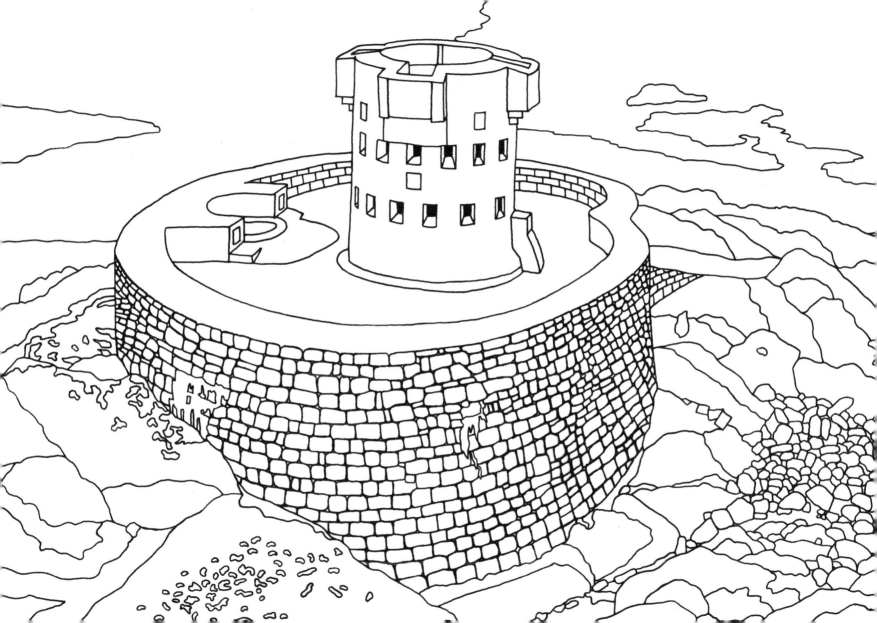

Guernsey ferry ▶

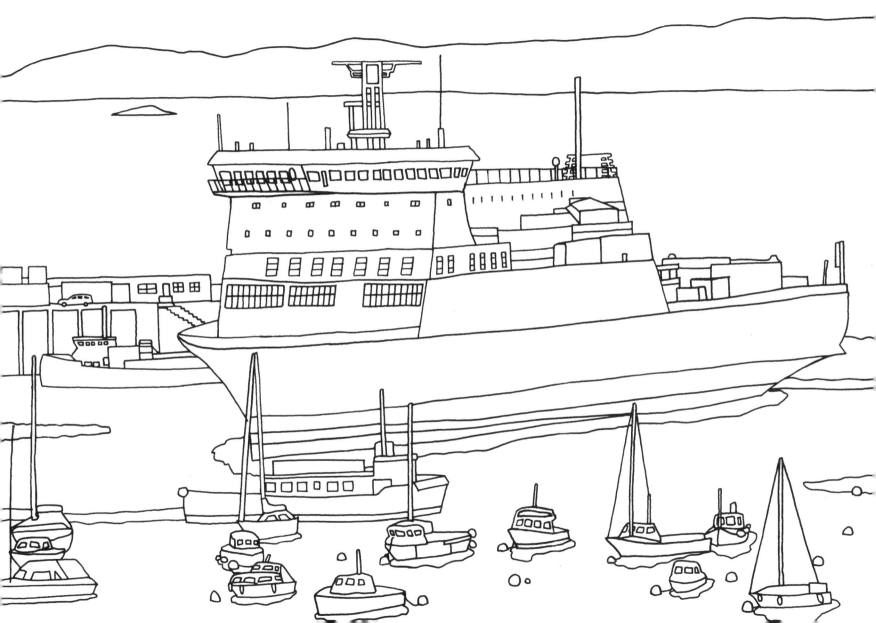

Jersey Lavender Farm ▸

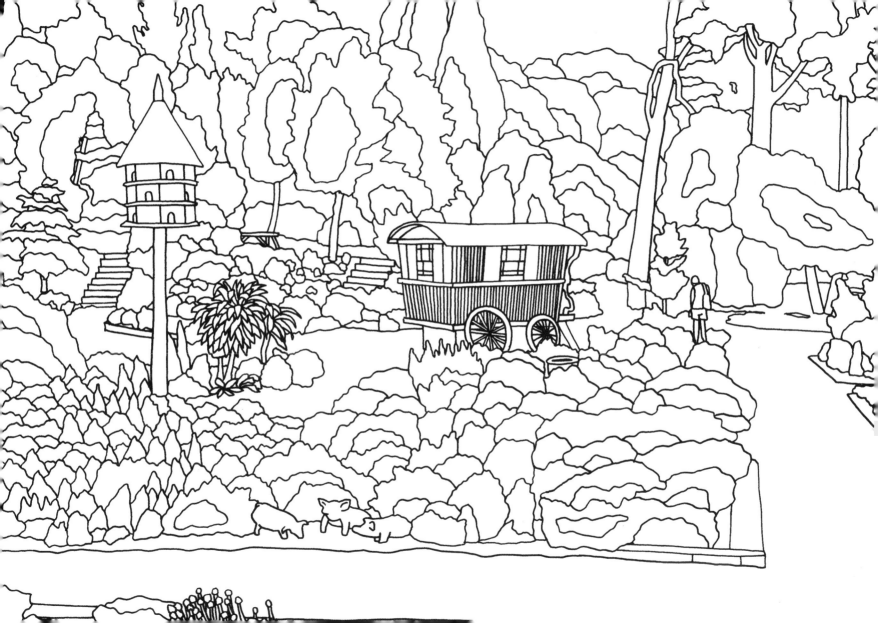

Picking Jersey Royal potatoes ▶

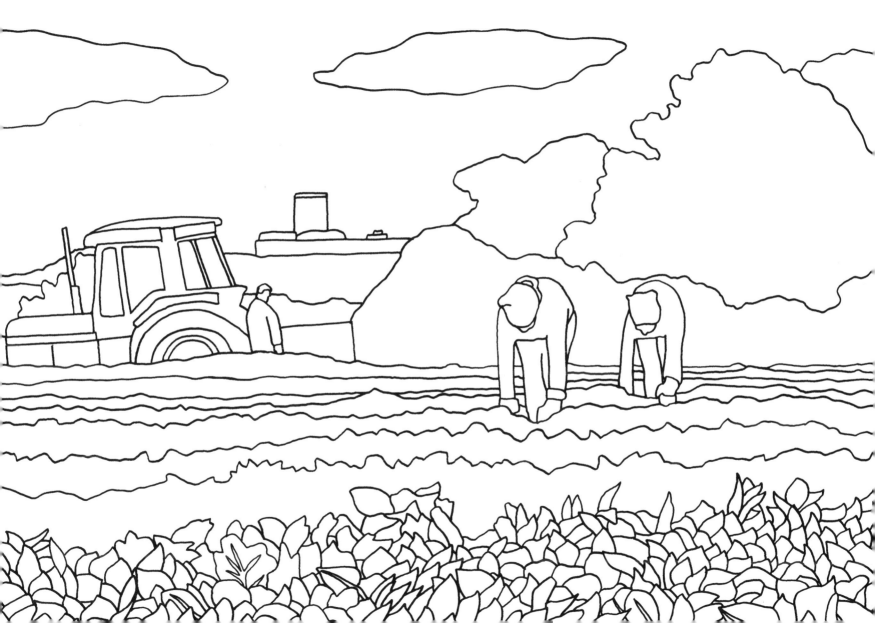

Shell Beach, Herm, Guernsey ▸

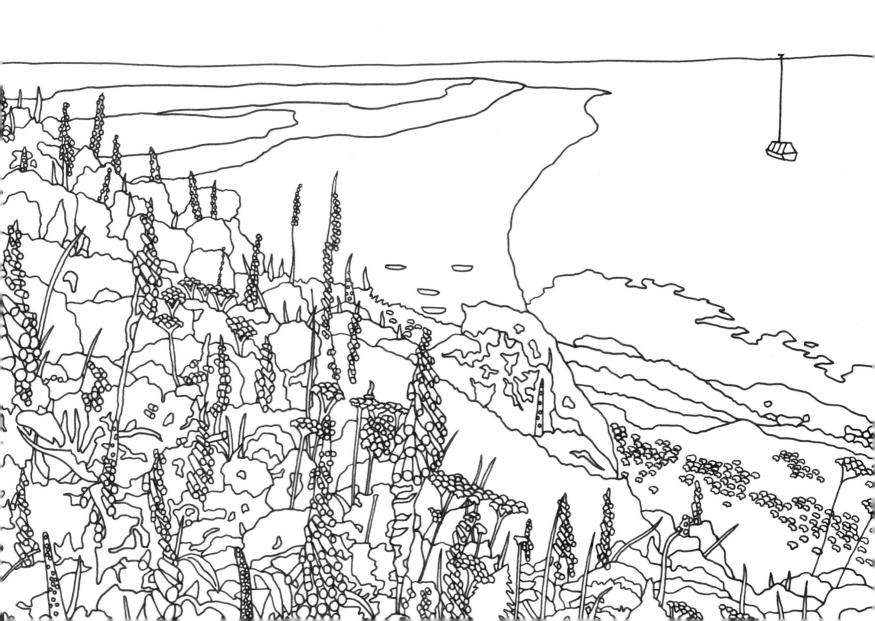

La Corbière lighthouse, Jersey ▸

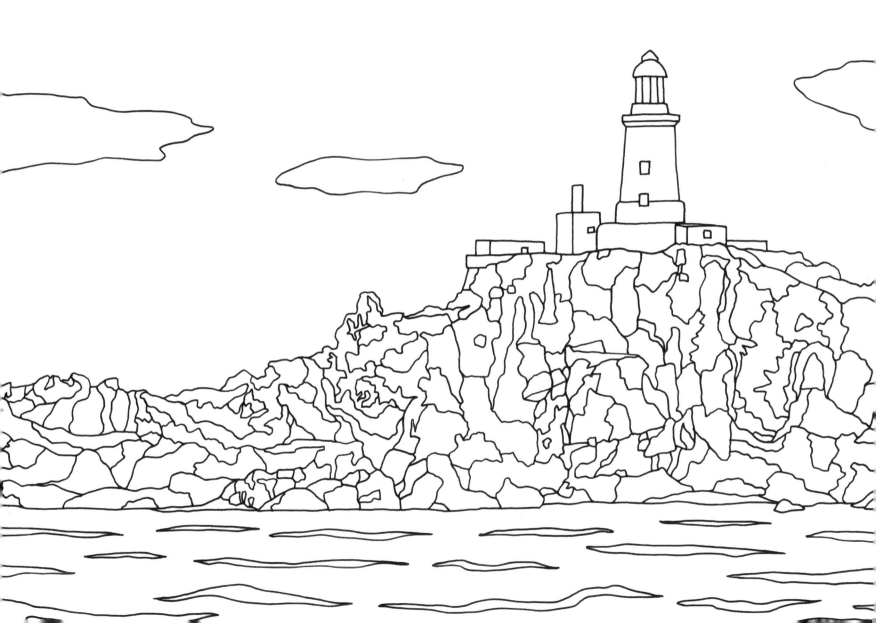

Elizabeth Castle, Jersey ▶

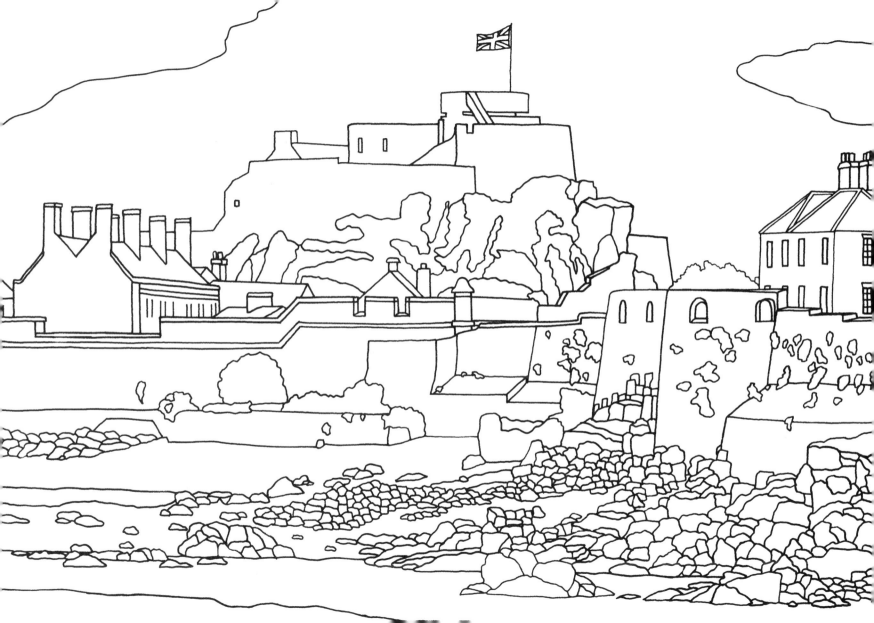

Gardens at Samares Manor, Jersey ▸

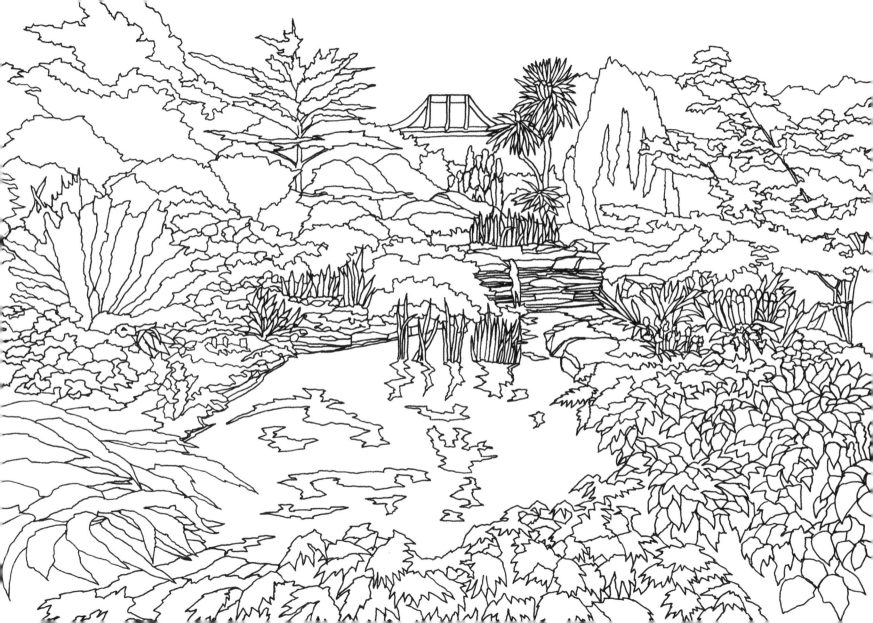

An early picture of Abraham de Gruchy & Co.,
King Street, St Helier, Jersey ▶

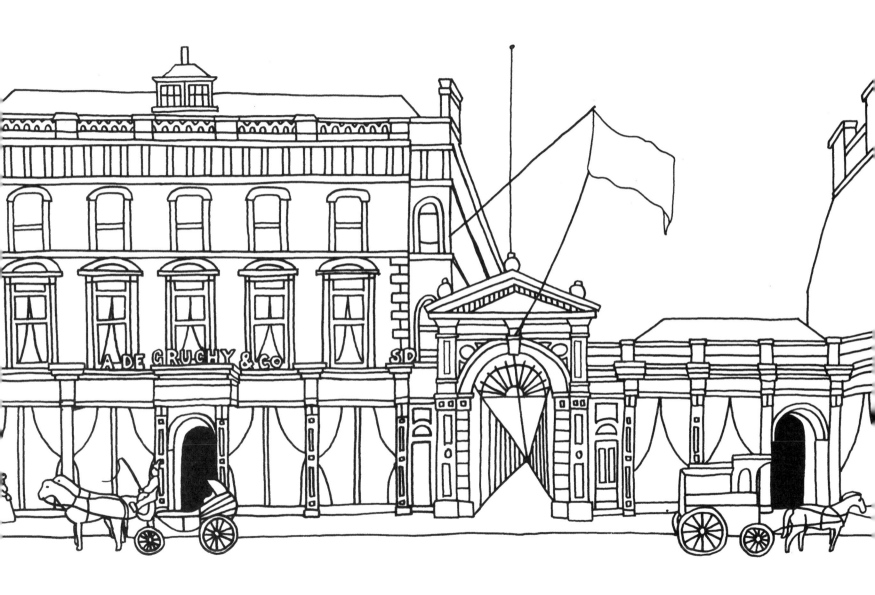

Bonne Nuit Harbour, Jersey ▸

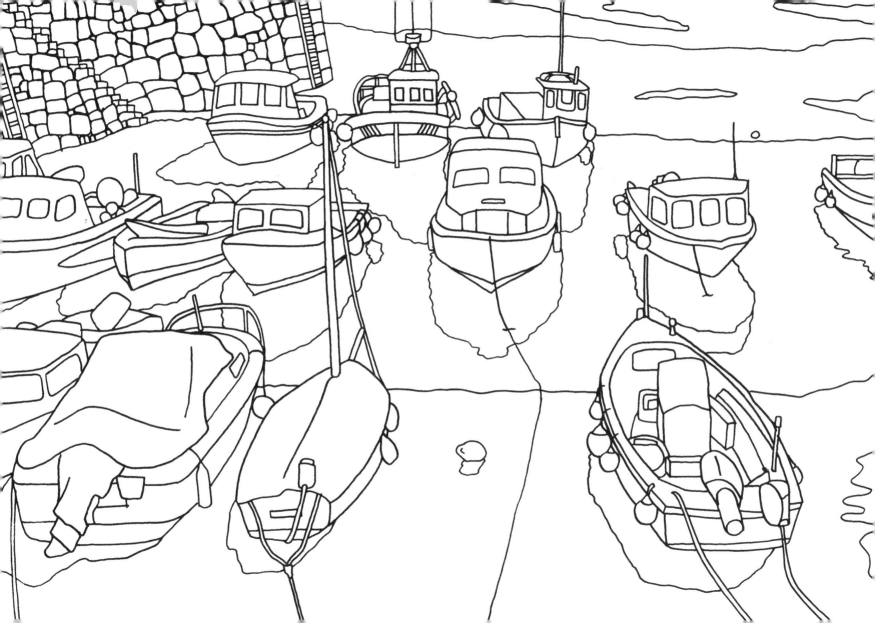

Hauteville House, Guernsey ▶

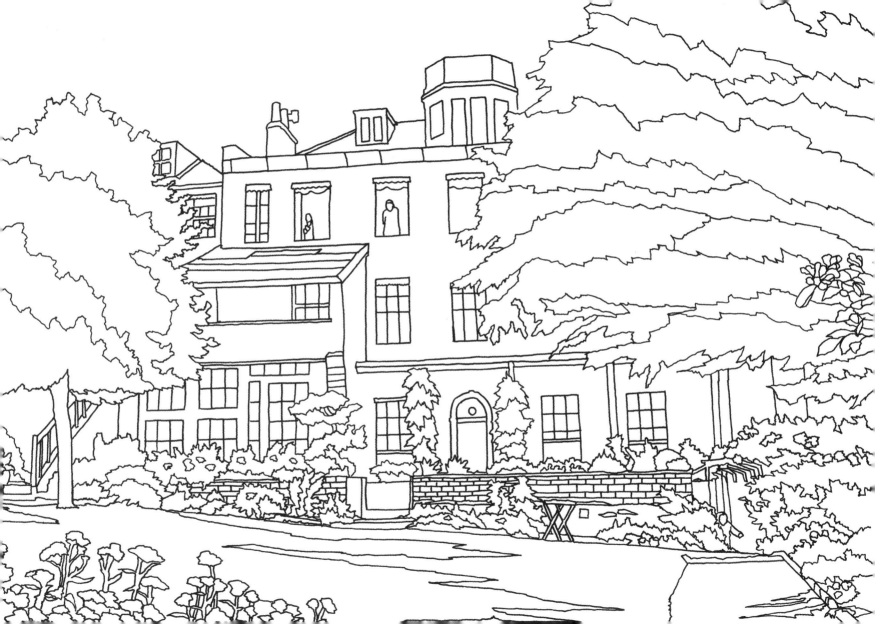

Cider press at Hamptonne
Country Life Museum, Jersey ▸

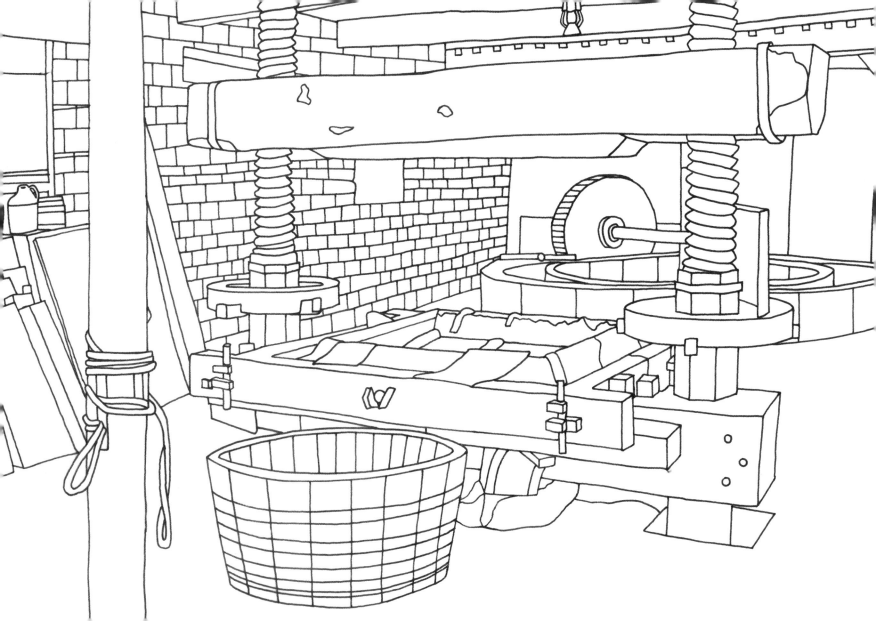

Cannons at Castle Cornet, Guernsey ▸

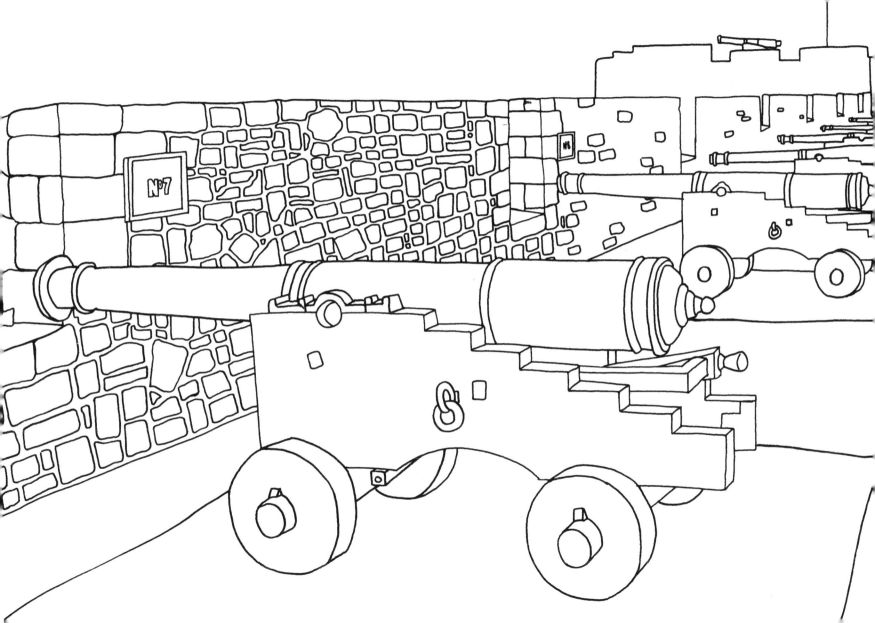

Sausmarez Manor, Guernsey ▸

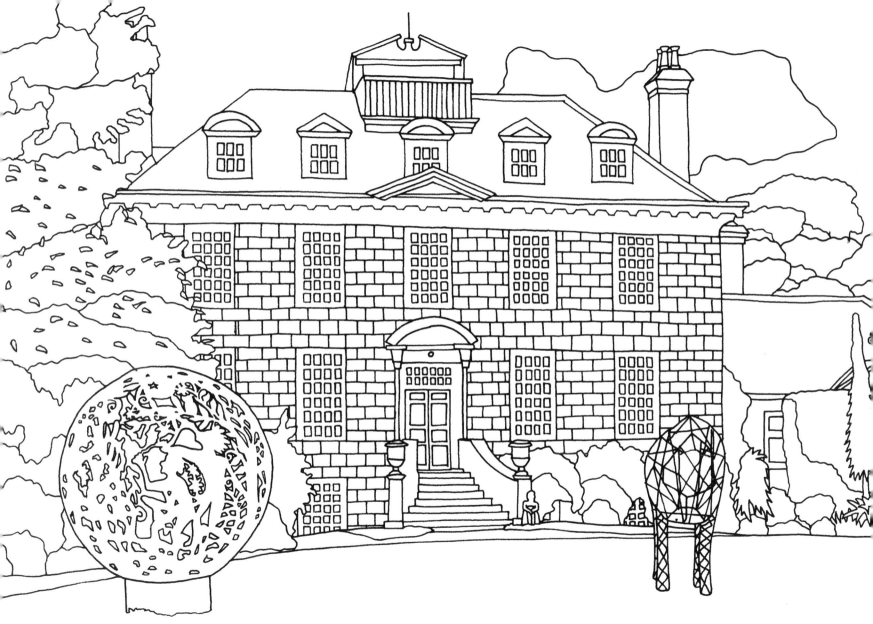

The Upper Walk, St Peter Port, Guernsey, 1900s ▶

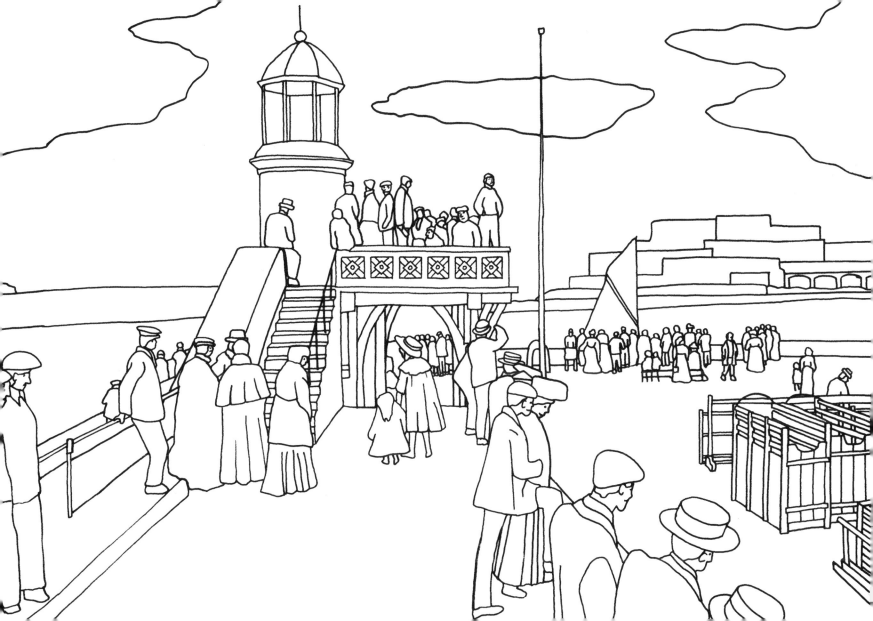

Castle Cornet, St Peter Port, Guernsey ▸

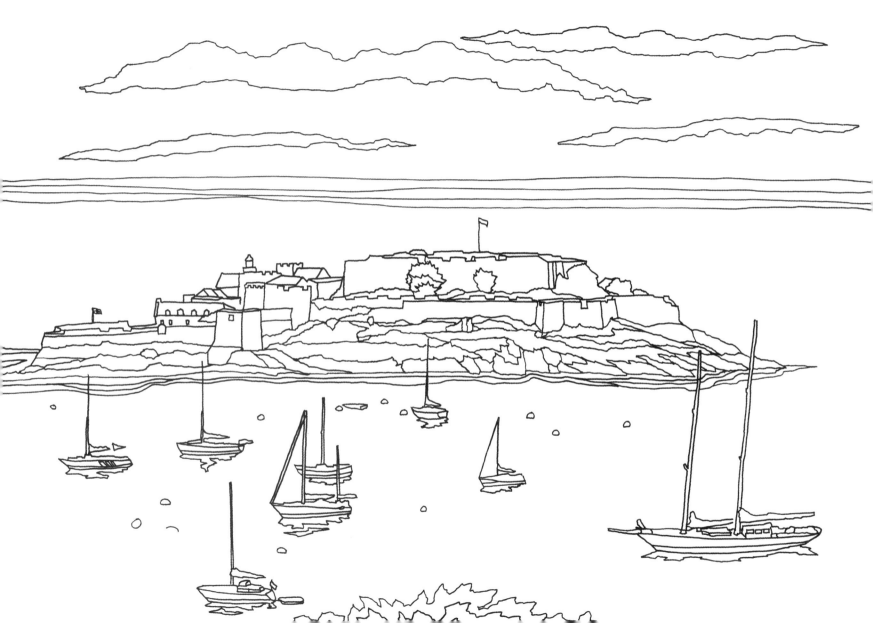

Cars arriving at Jersey, 1965 ▶

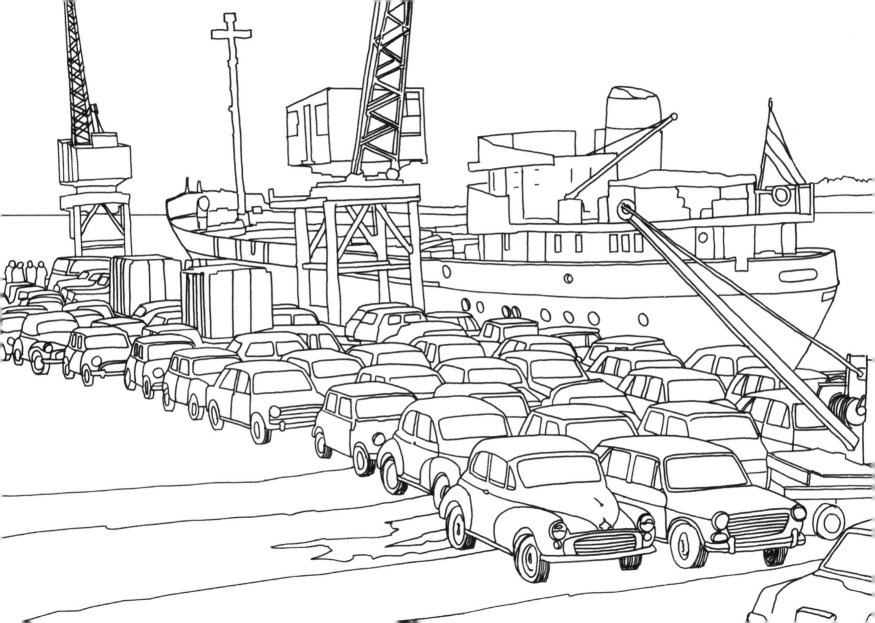

Horse and carriage on La Coupée, Sark ▶

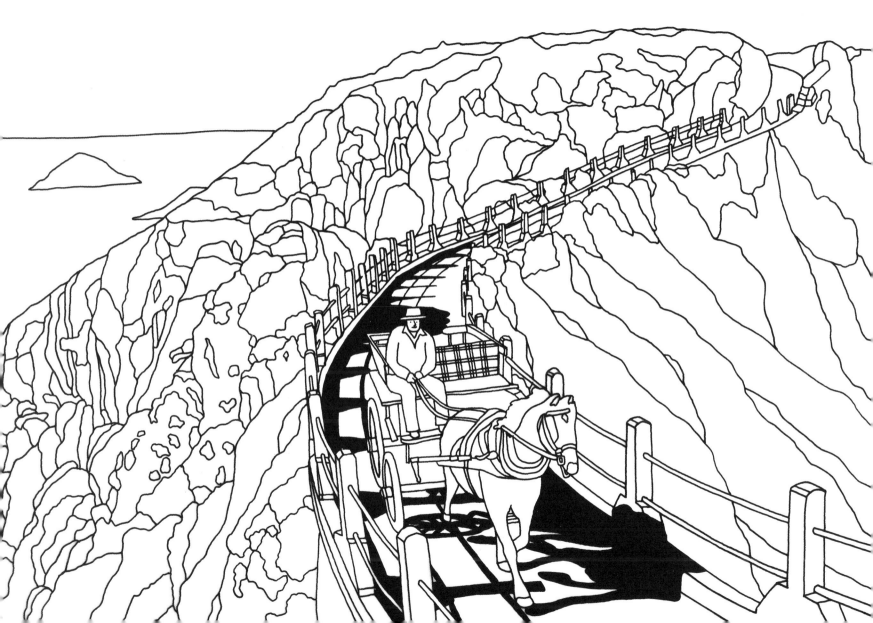

St Anne Church, Alderney ▶

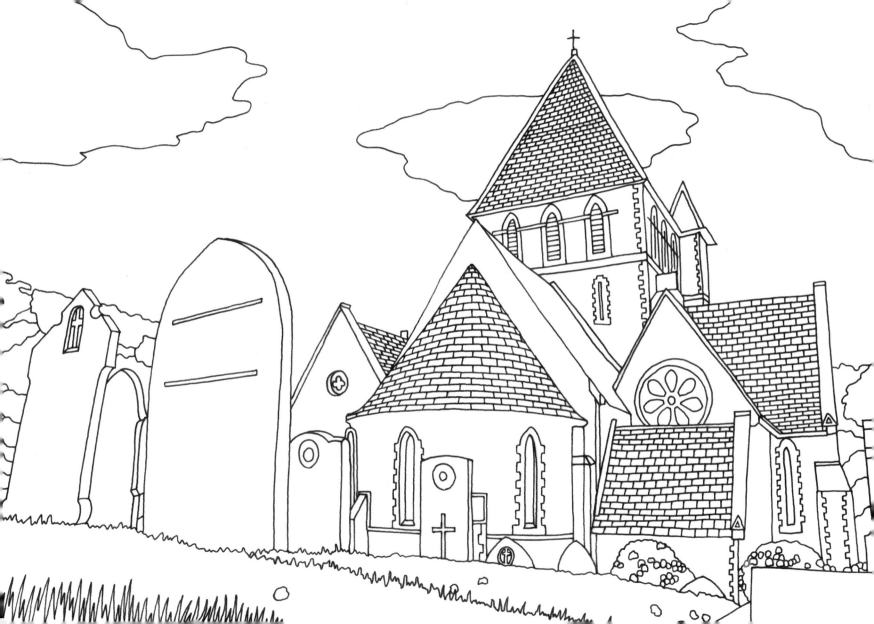

The Little Chapel, St Peter Port, Guernsey ▶

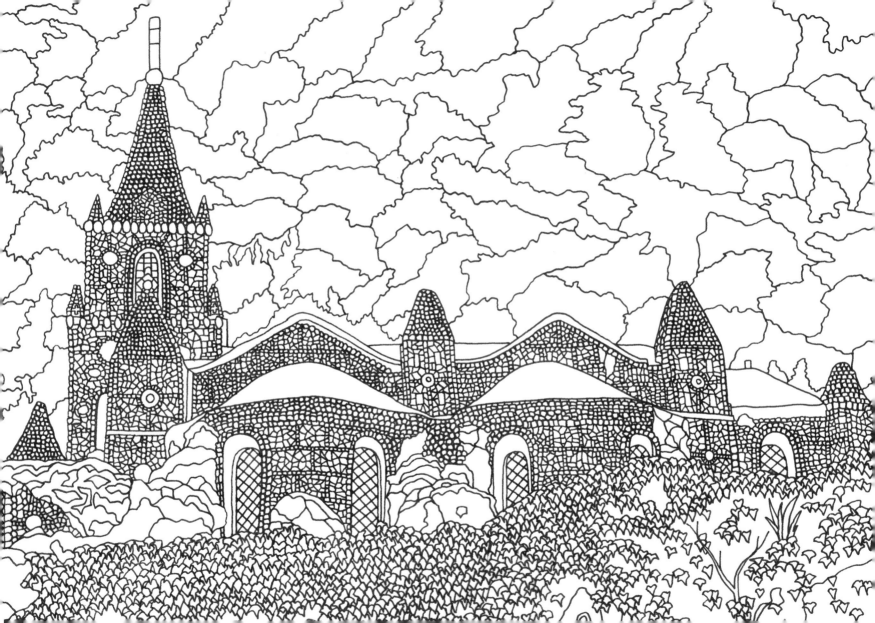

St Peter Port, Guernsey, *c.* 1910 ▸

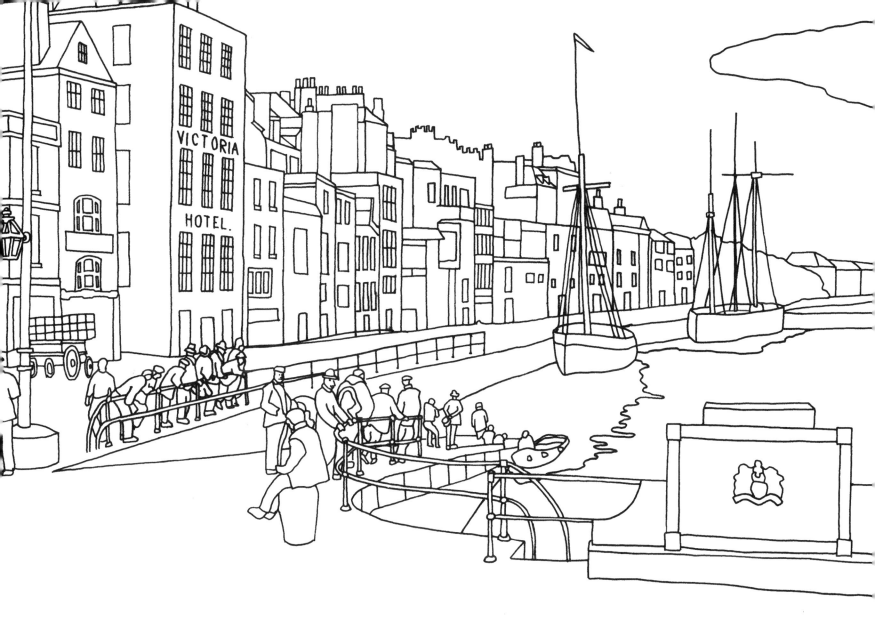

The Hungry Man, Rozel Bay, Jersey ▸

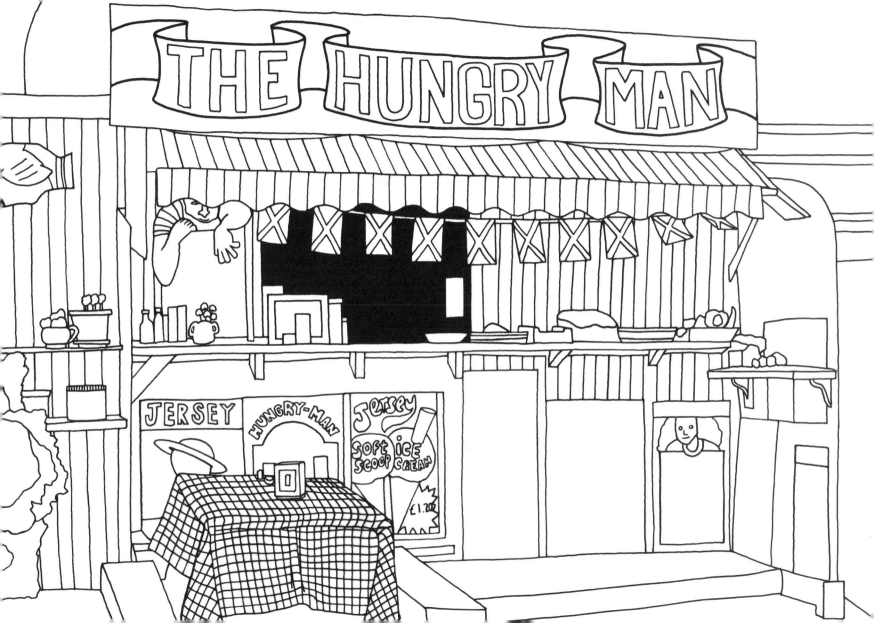

Maritime Museum, Jersey ▶

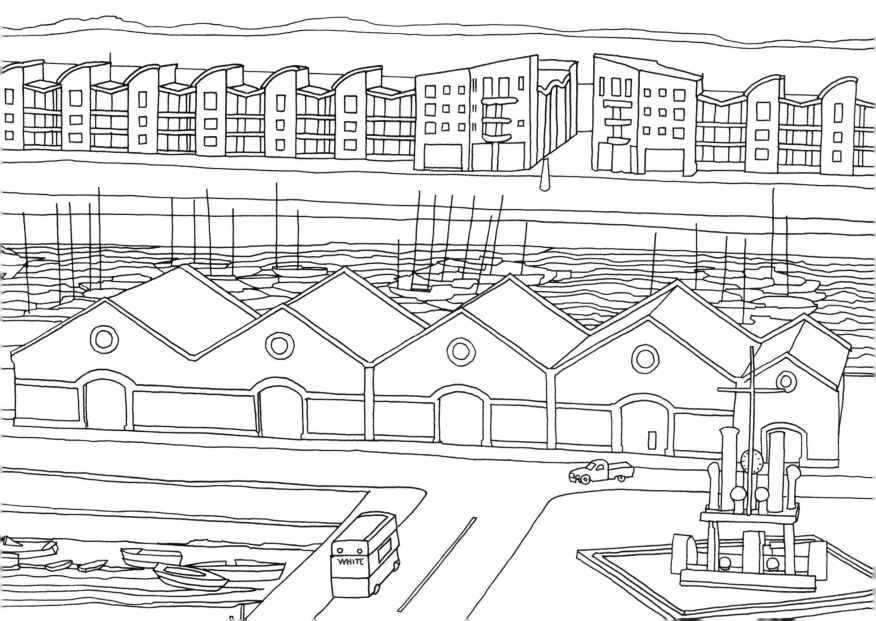

Sea kayaks at Les Écréhous, Jersey ▶

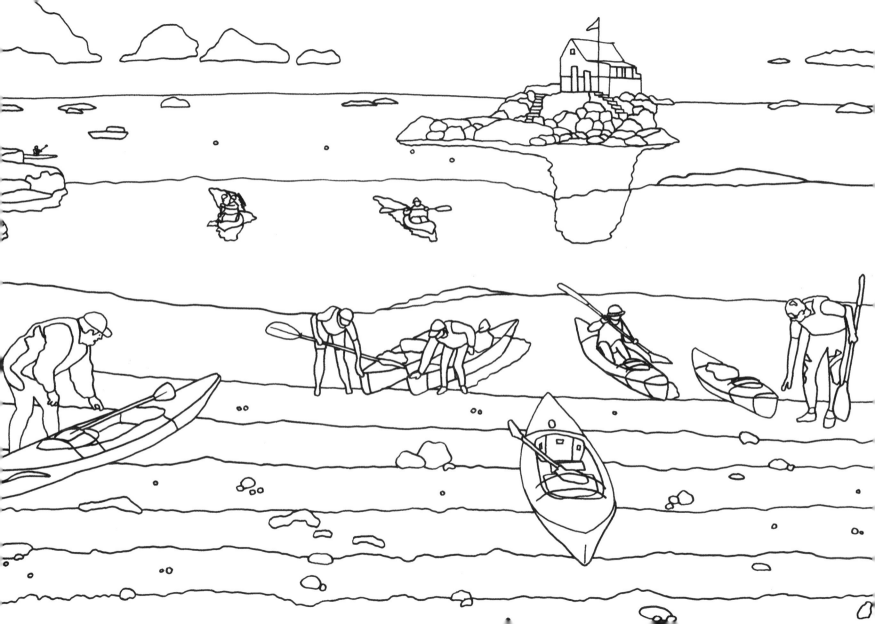

Liberation Square, Jersey ▶

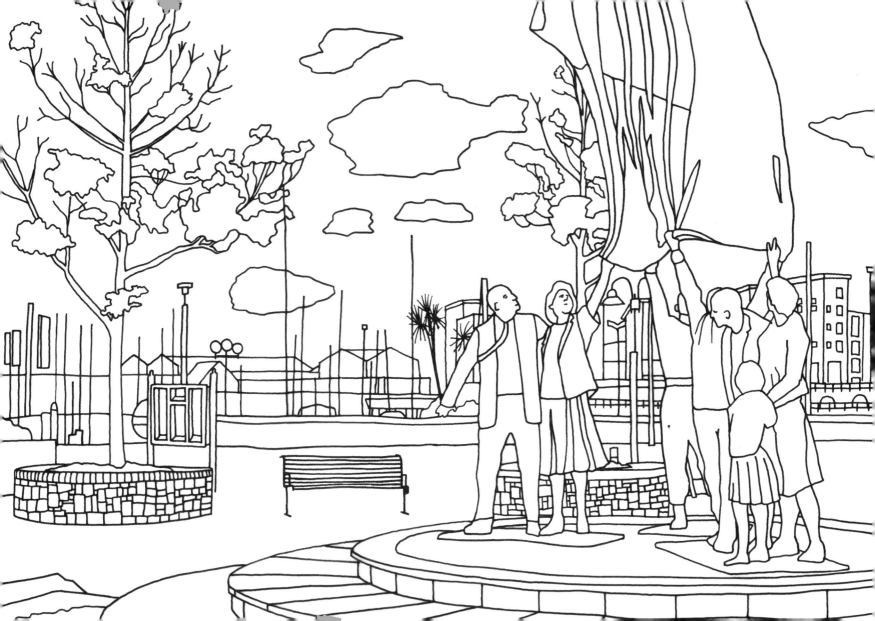

Guernsey Museum, Candie Gardens ▸

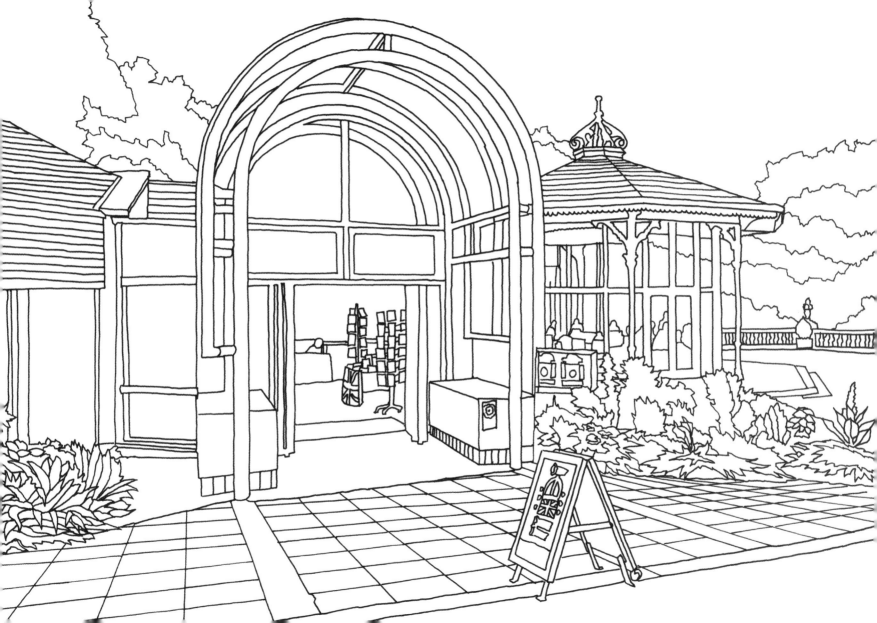

Old-fashioned transport on The Quay, Sark, 1937 ▸

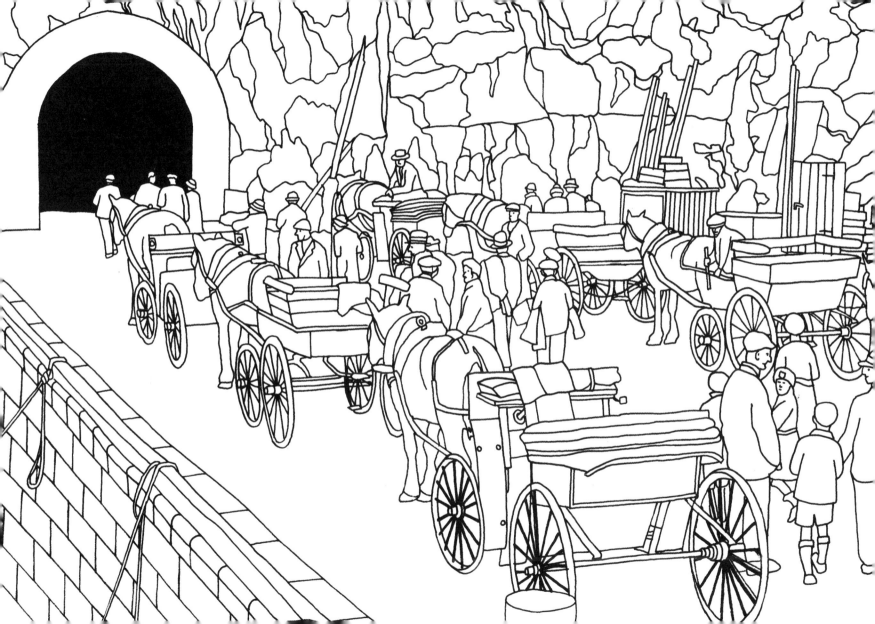

Victor Hugo statue, Candie Gardens, Guernsey ▸

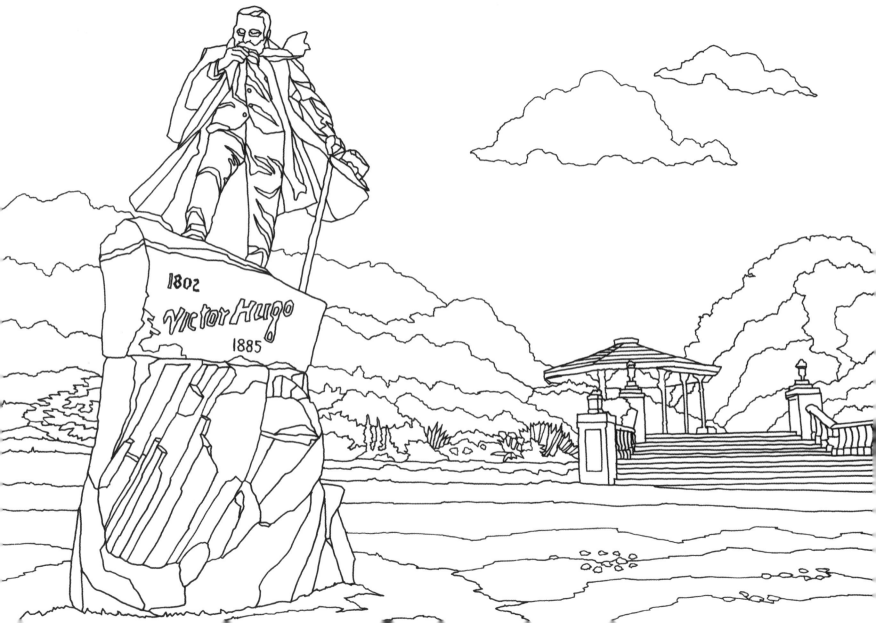

Sand racing at Vazon Bay, Guernsey ▶

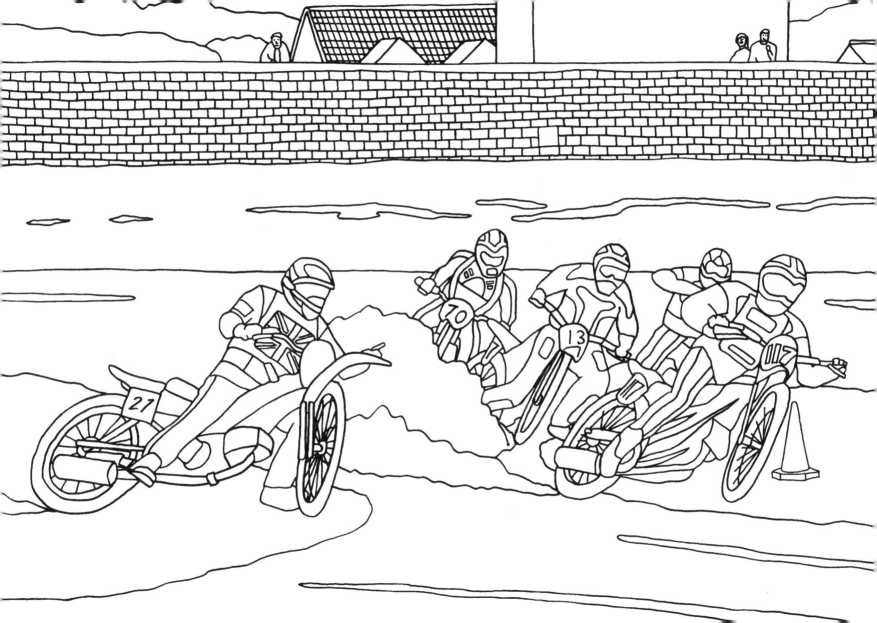

Jersey War Tunnels shuttle bus ▶

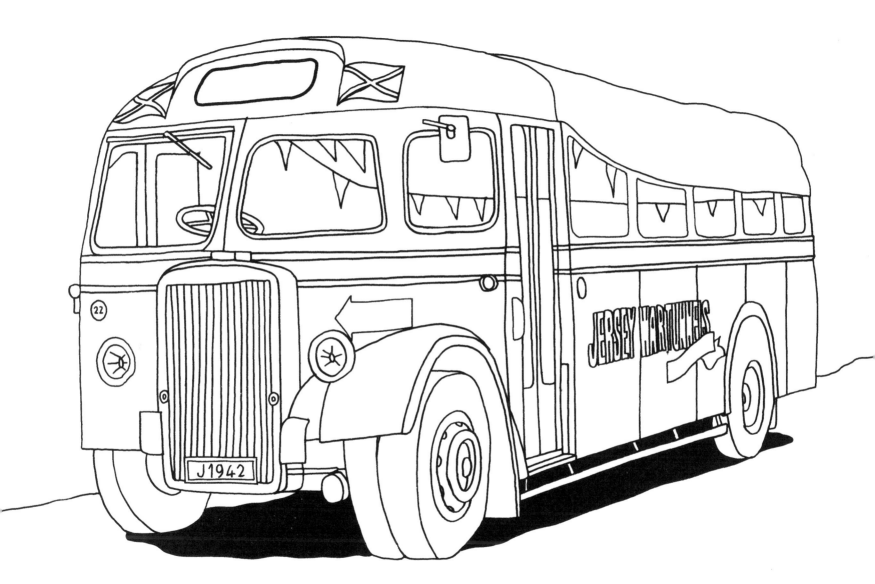

Flamingos at Durrell Wildlife Park, Jersey ▶

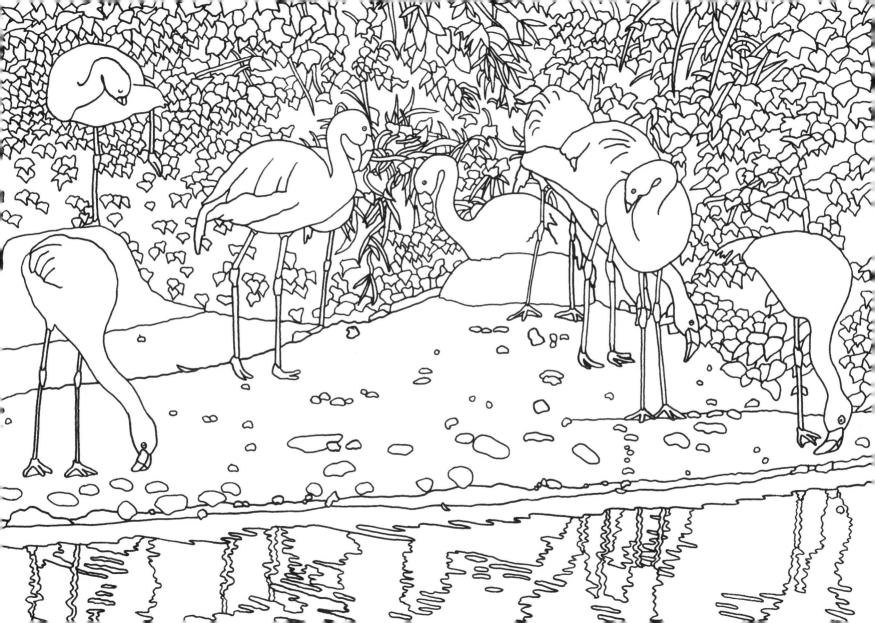

La Seigneurie Gardens, Sark ▶

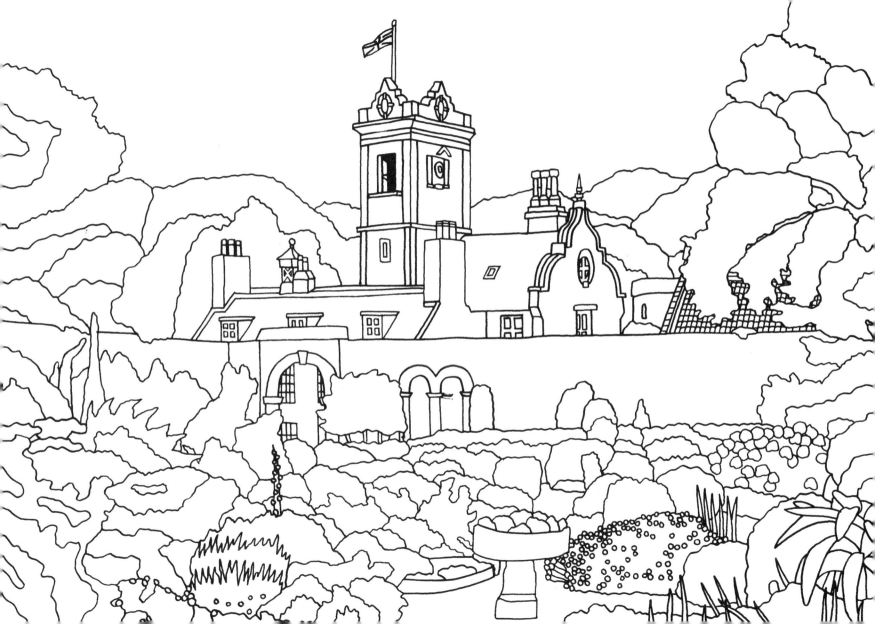

La Hougue Bie, Jersey ▸

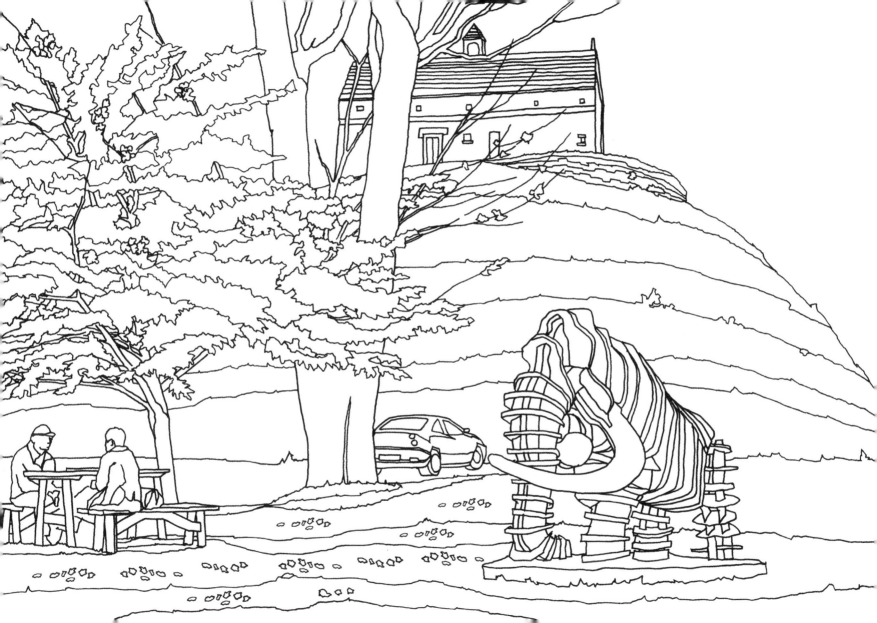

Saline Bay, Guernsey ▸

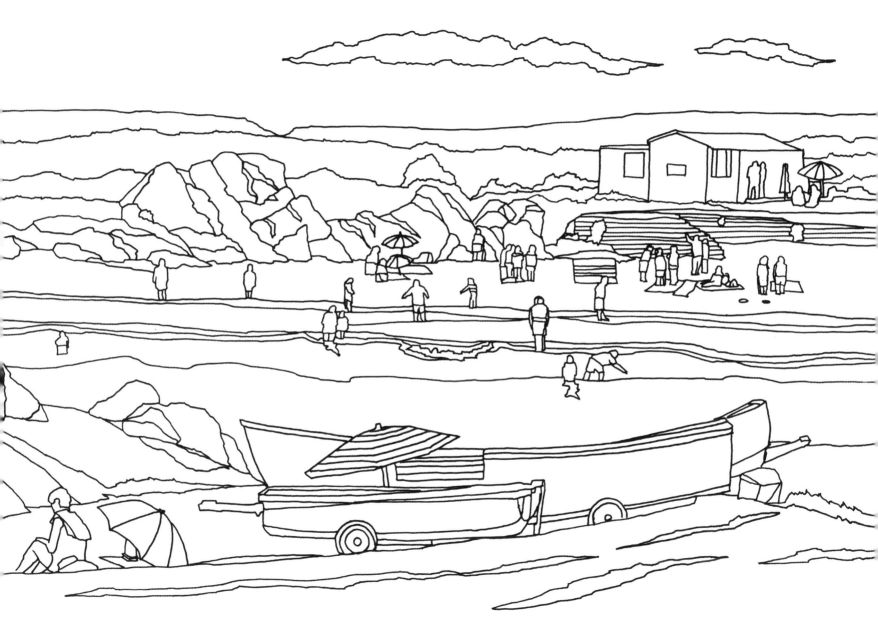

The *Alert* in Creux Harbour, Sark, 1900s ▸

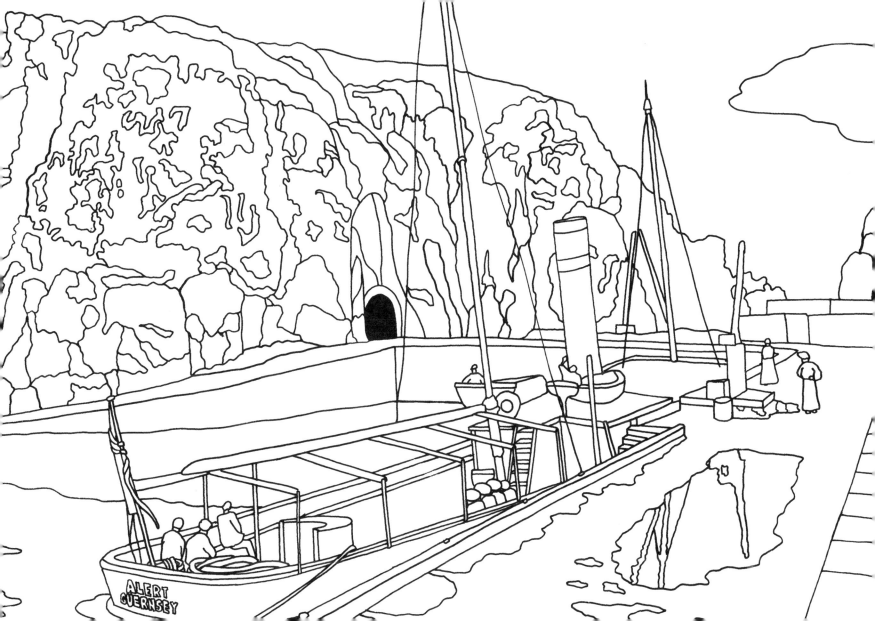

Guernsey cattle in Saint Saviour, Guernsey ▸

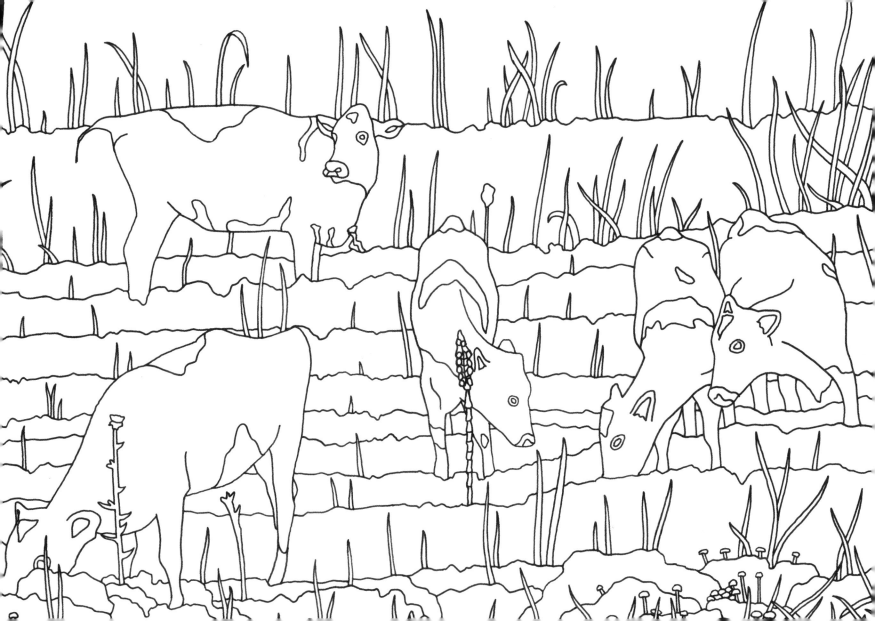

Grosnez Castle, Jersey ▶

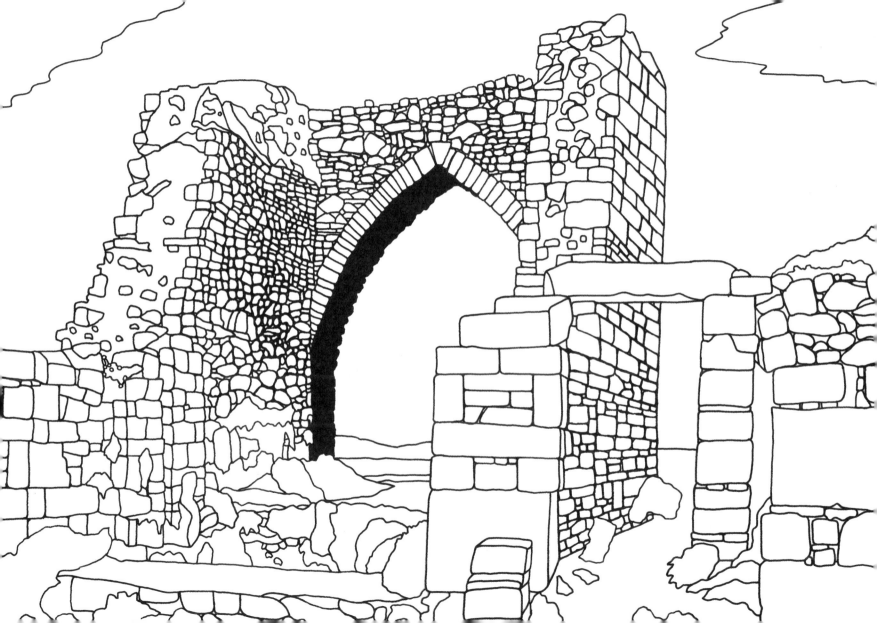

Mont Orgueil Castle, Jersey ▶

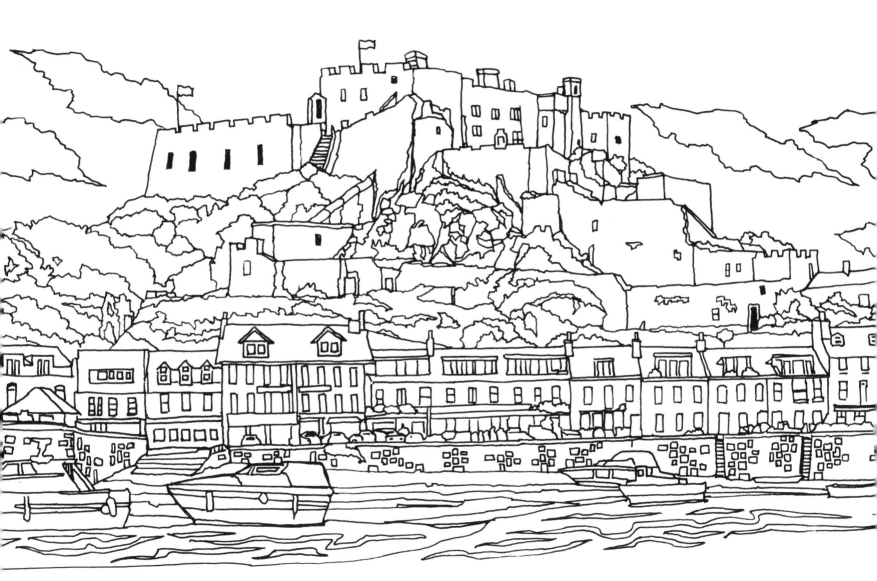

Guernsey fishermen, 1908 ▶

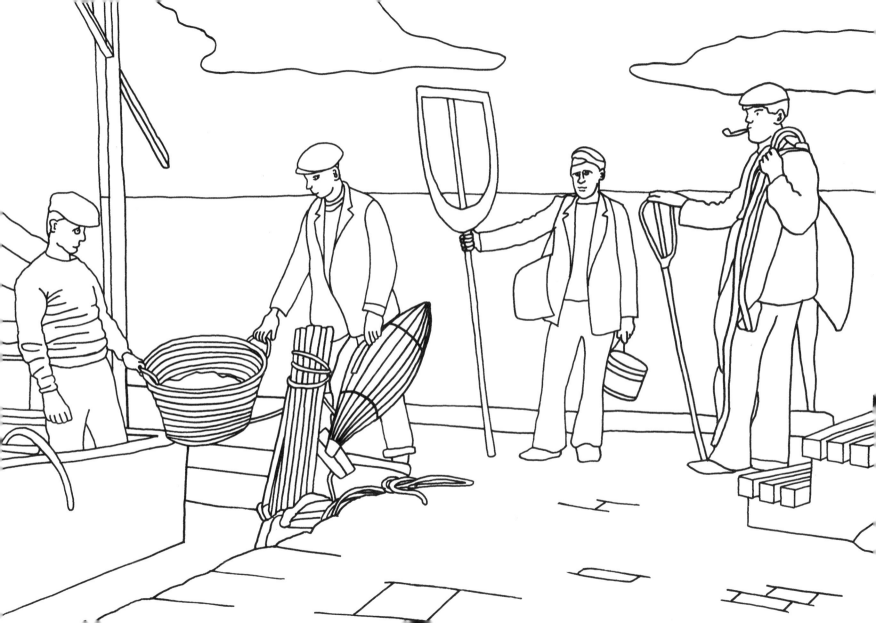

Auringy Harbour, Alderney ▸

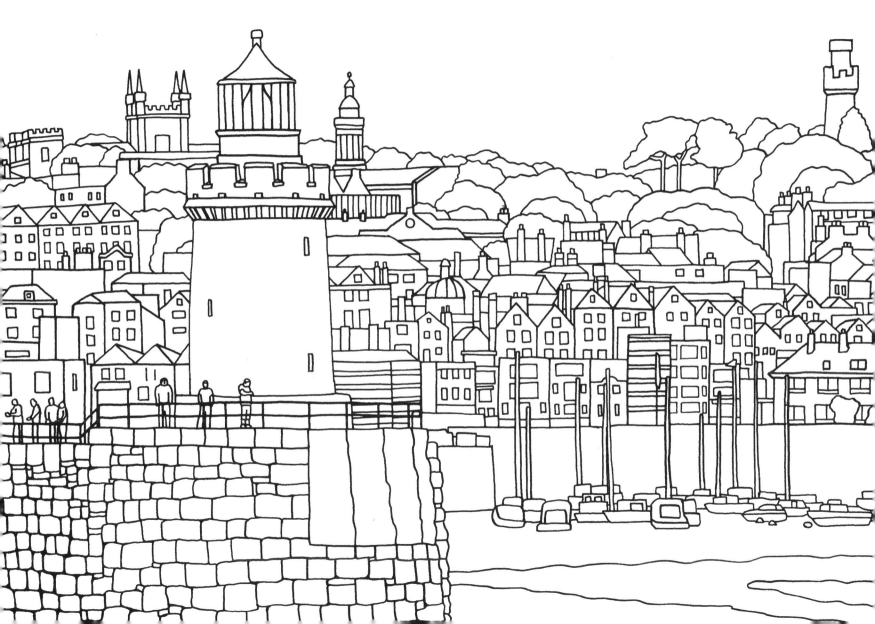

St Aubin's Bay, Jersey ▶

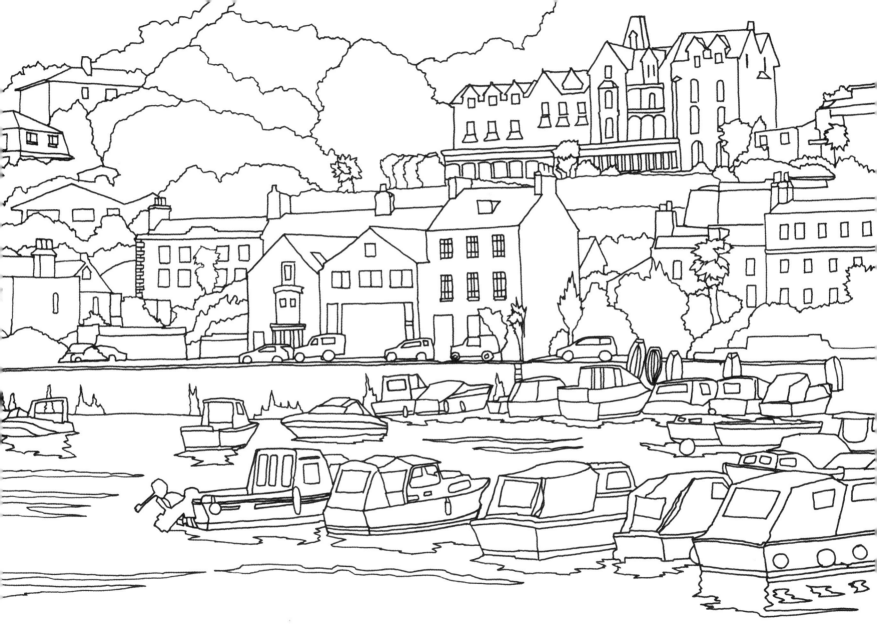

Aerial view of Mont Orgueil Castle, Jersey ▶

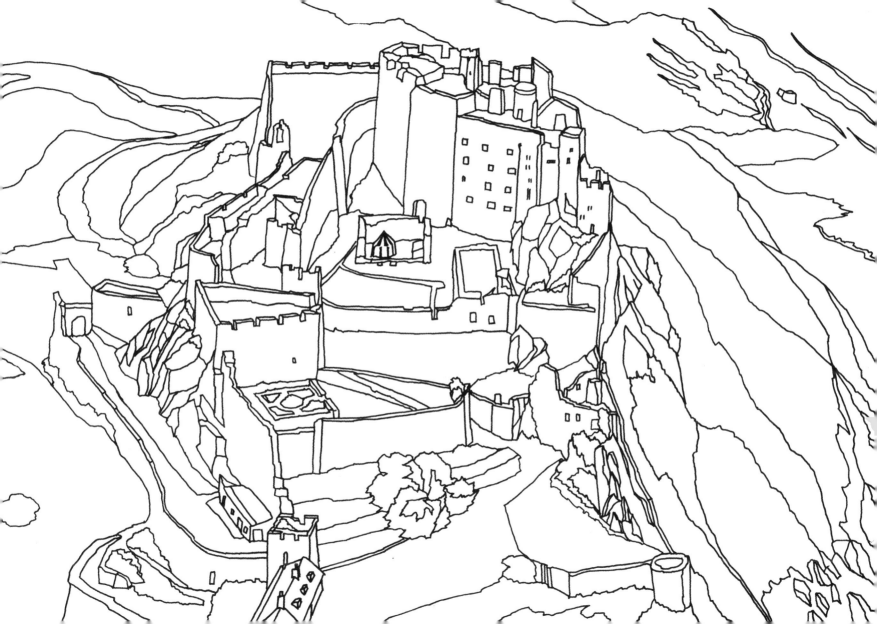